How To Draw Stuff

By

Scott E. Sutton

Hi, I'm Jeeter, one of the characters from the "Family of Ree" books. They were written and illustrated by Scott E. Sutton.

Scott sent me and some of my BeeBee friends here to teach you something.

Hi!

We are going to teach you HOW TO DRAW STUFF!

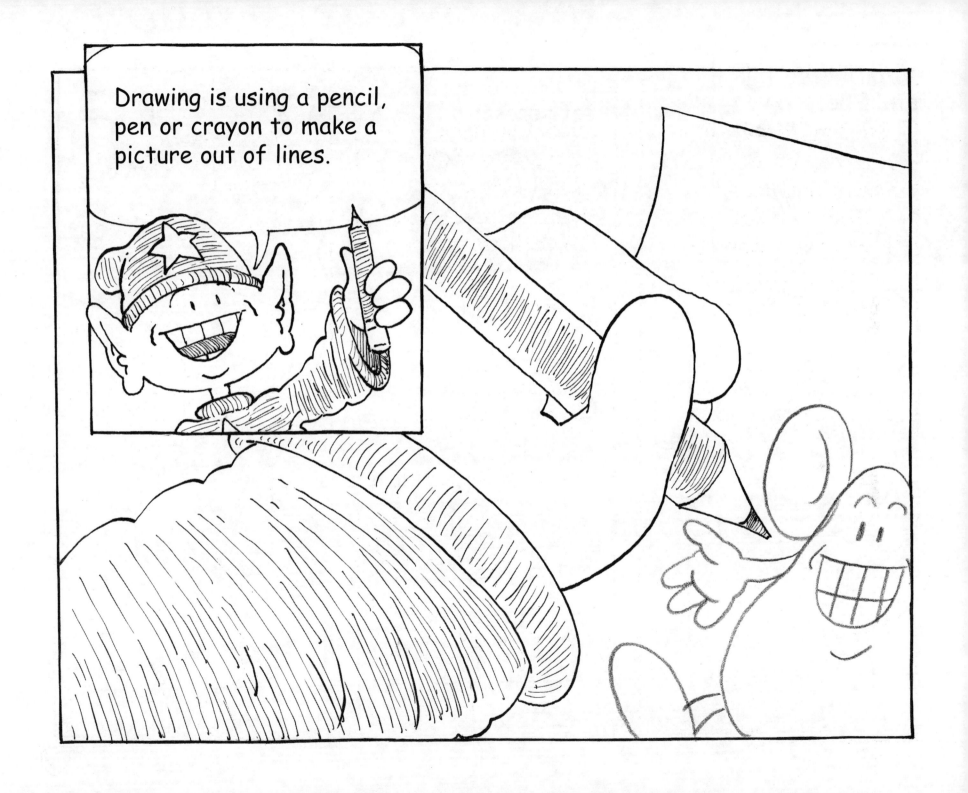

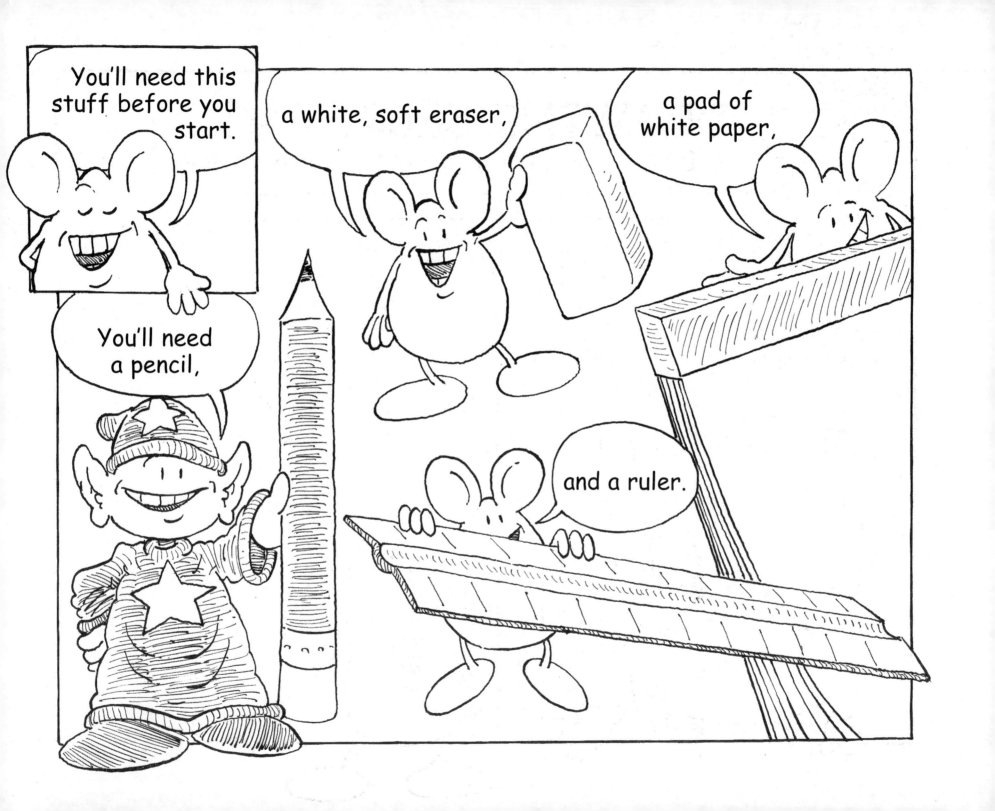

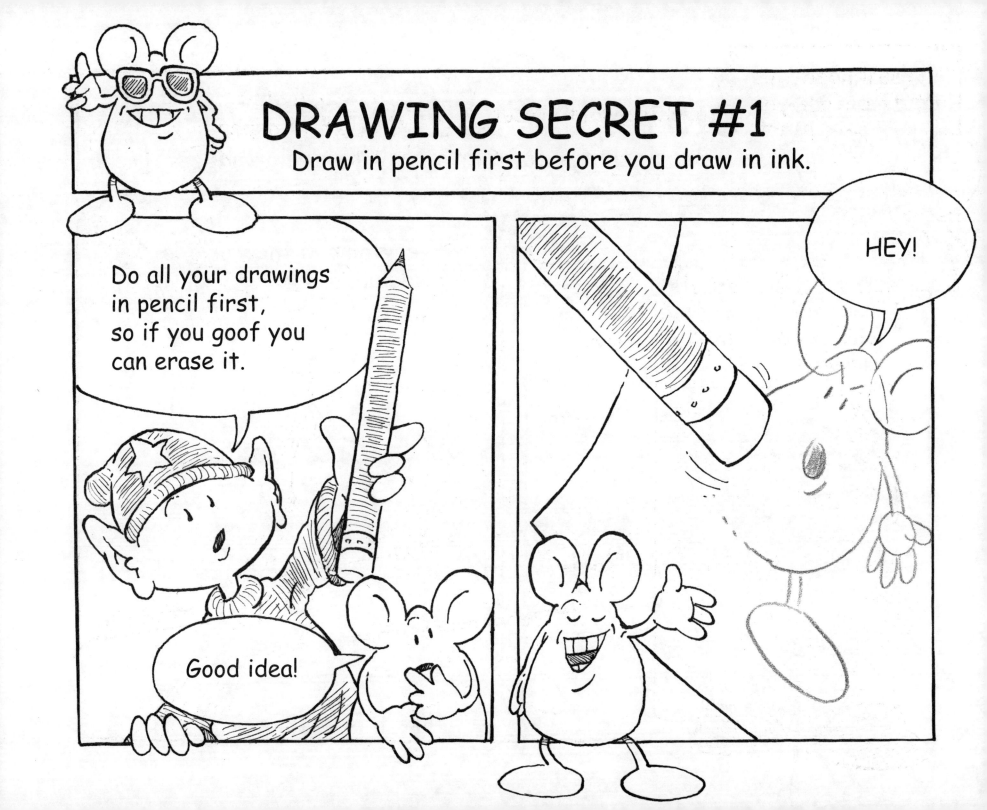

DRAWING SECRET #2
Break things down into easy-to-draw shapes.

When you draw stuff, use pencil first and break things down into easier-to-draw shapes!

Everything in the world is made up of smaller shapes . . .

YIKES!

. . . like this BeeBee.

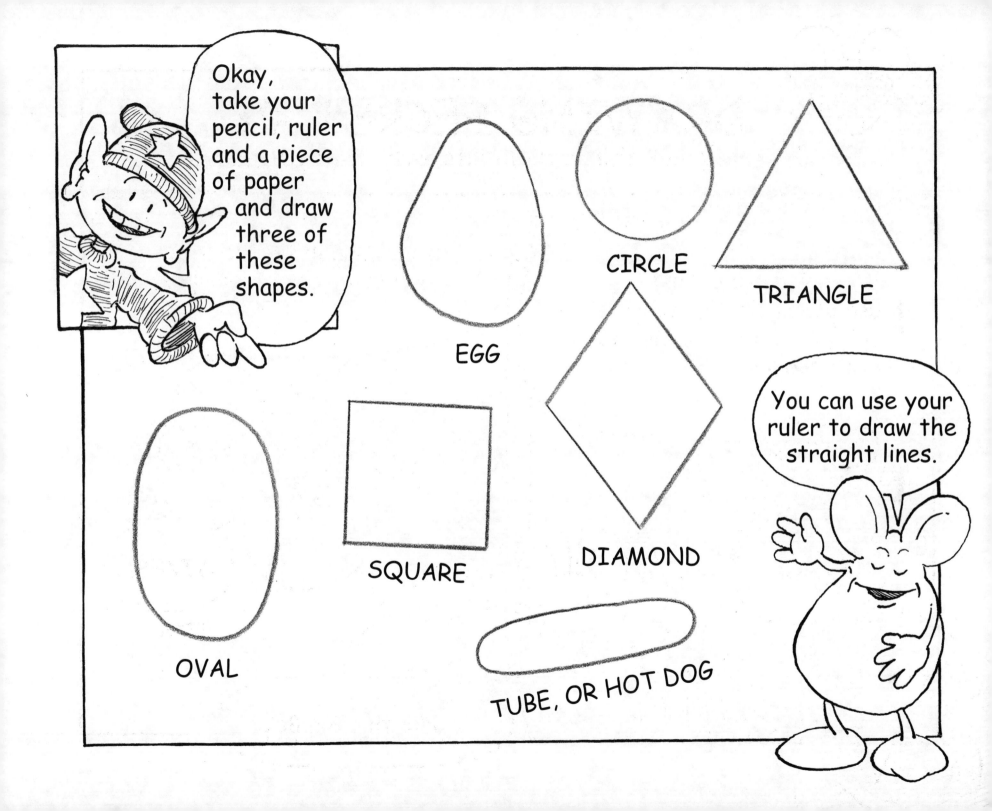

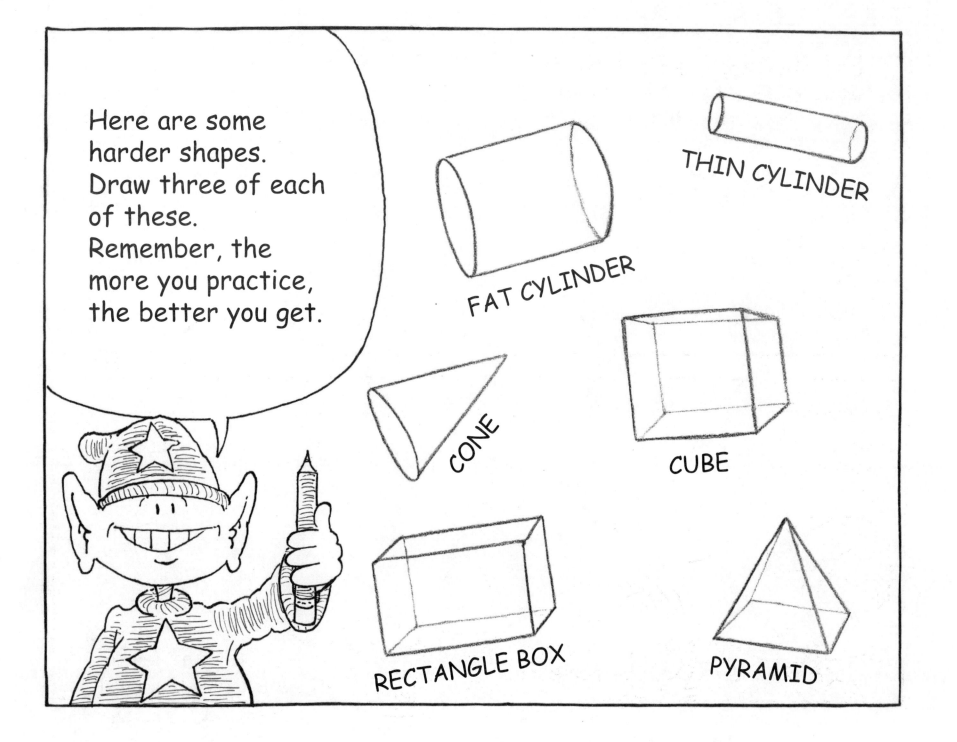

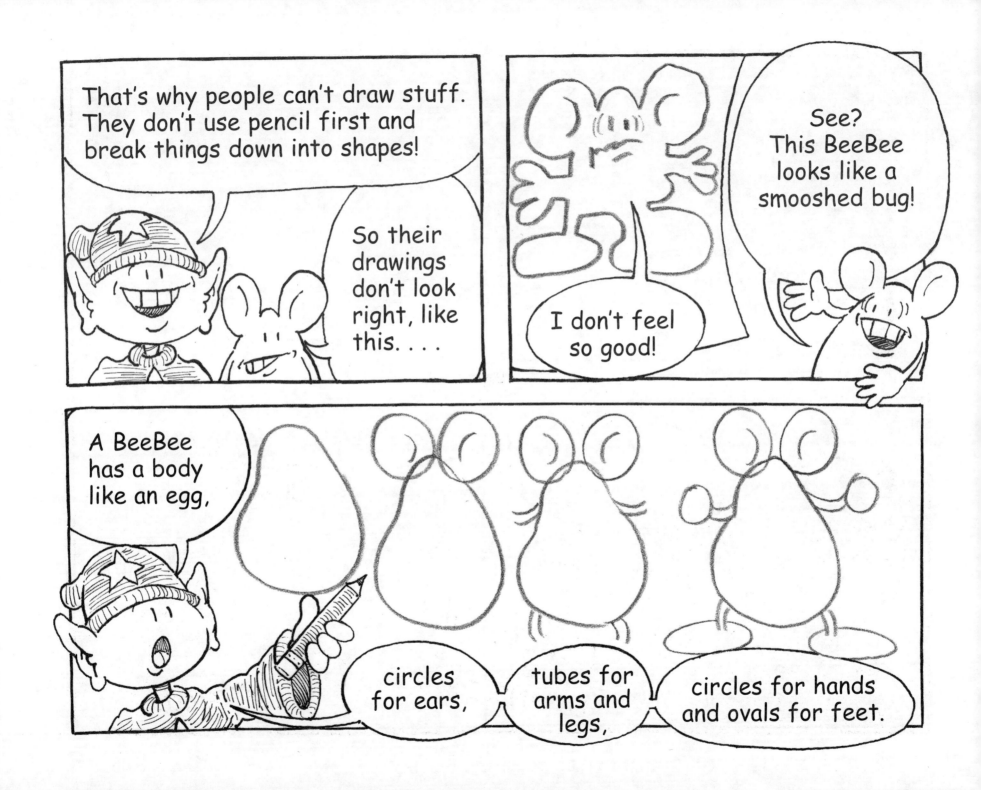

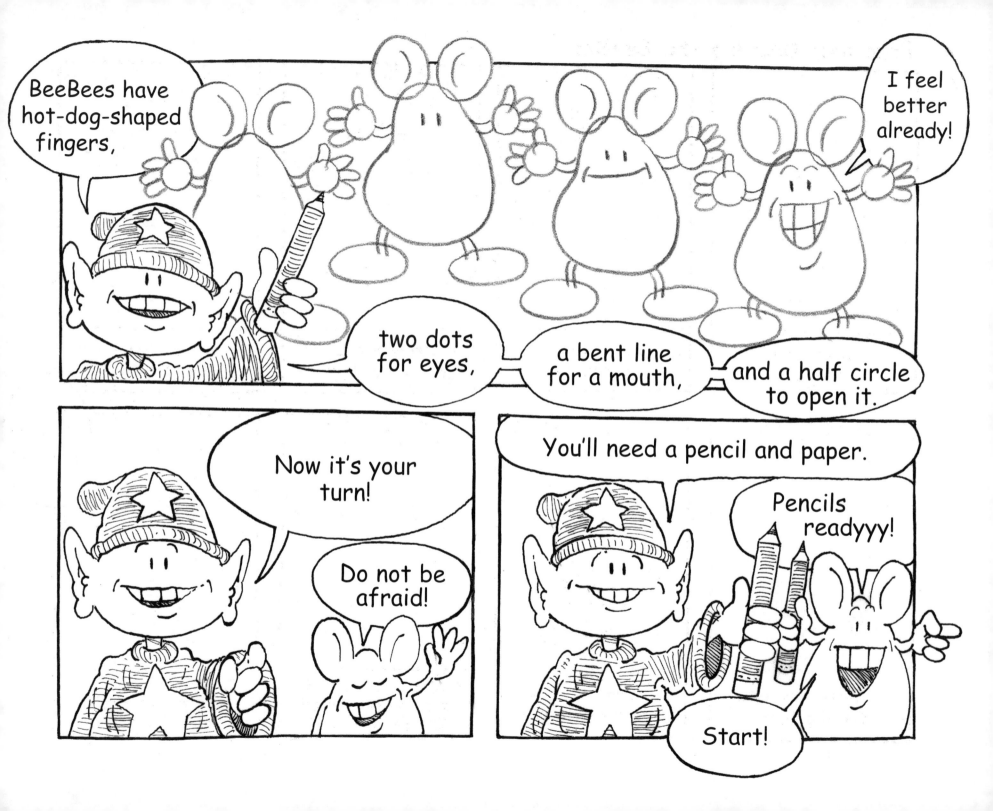

Practice: Drawing the BeeBee

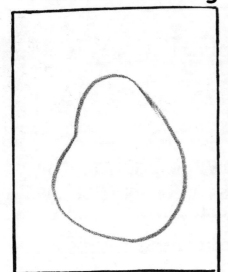

1. Draw an egg shape.

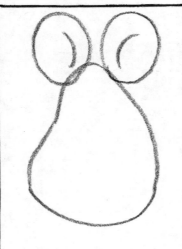

2. Draw two circles at the top.

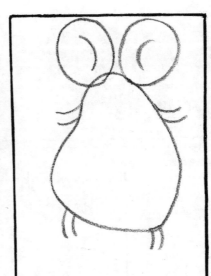

3. Draw tubes for arms and legs.

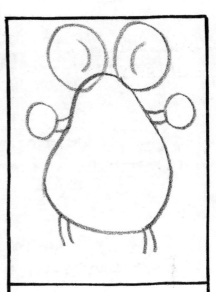

4. Draw circles for the hands.

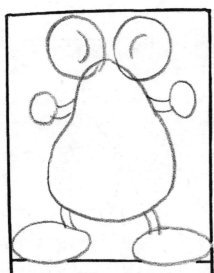

5. Draw two ovals for the feet.

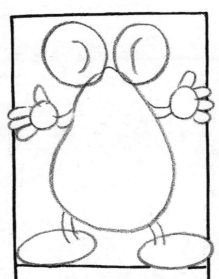

6. Draw hot-dog-shaped fingers.

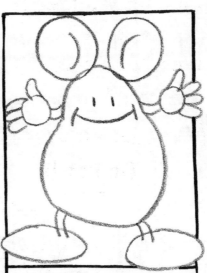

7. Draw two dots for eyes and a curved line for a mouth.

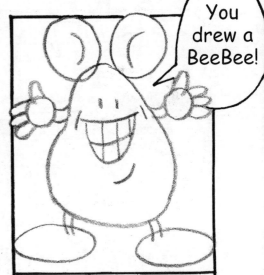

You drew a BeeBee!

8. Open the mouth with a half circle and make teeth.

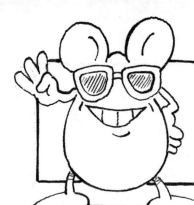

DRAWING SECRET #3
Draw lightly.

When you draw in pencil, draw lightly, so it erases easily.

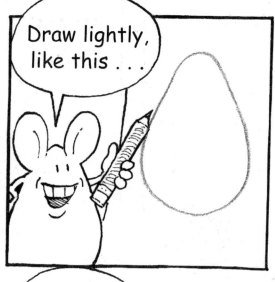

Draw lightly, like this . . .

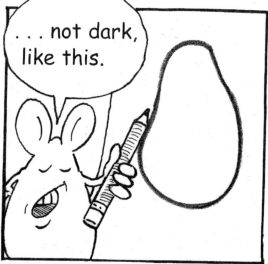

. . . not dark, like this.

Now, go back to the last page and draw another BeeBee like you were taught.

When you're done, go to the next page.

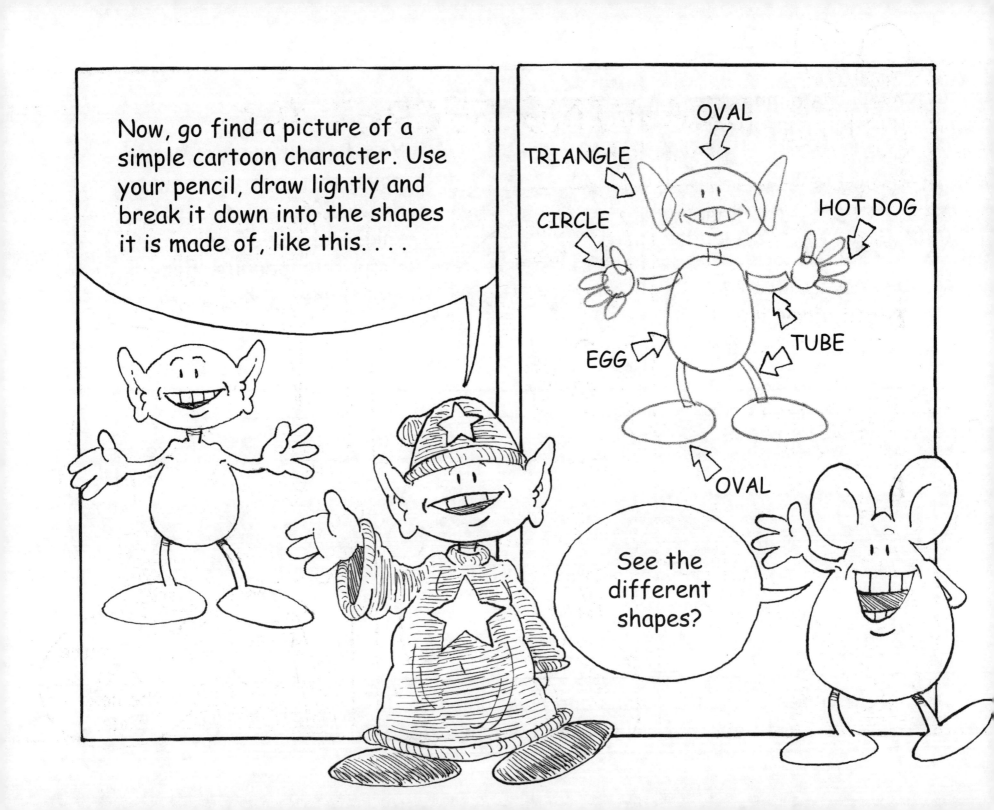

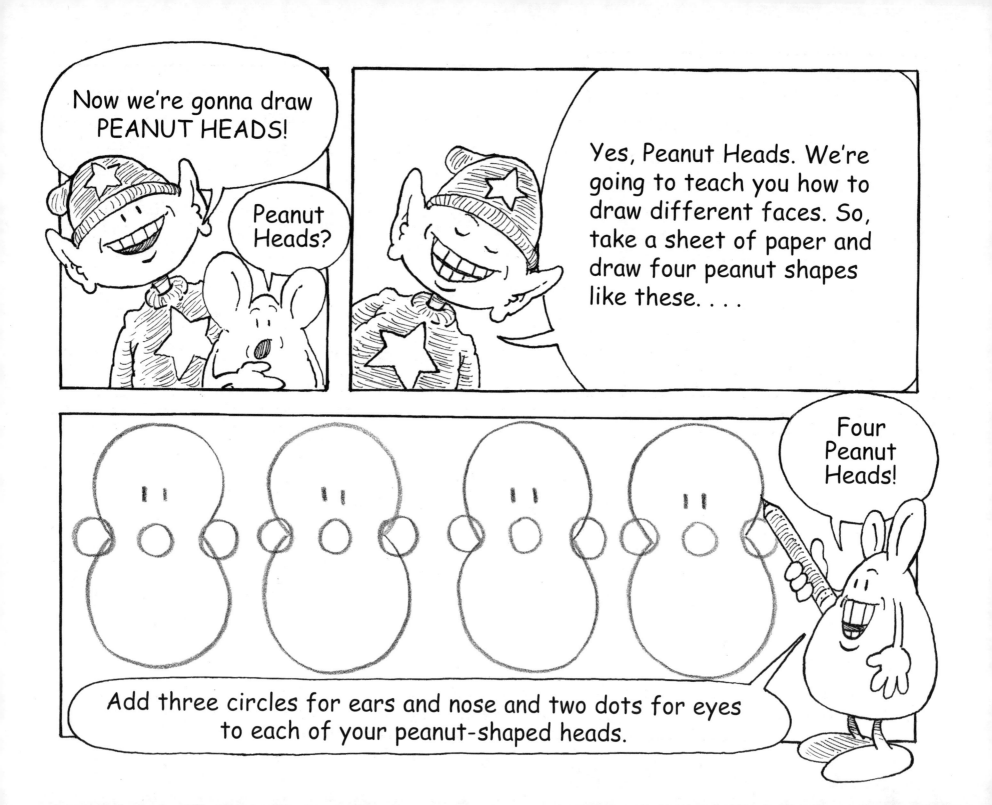

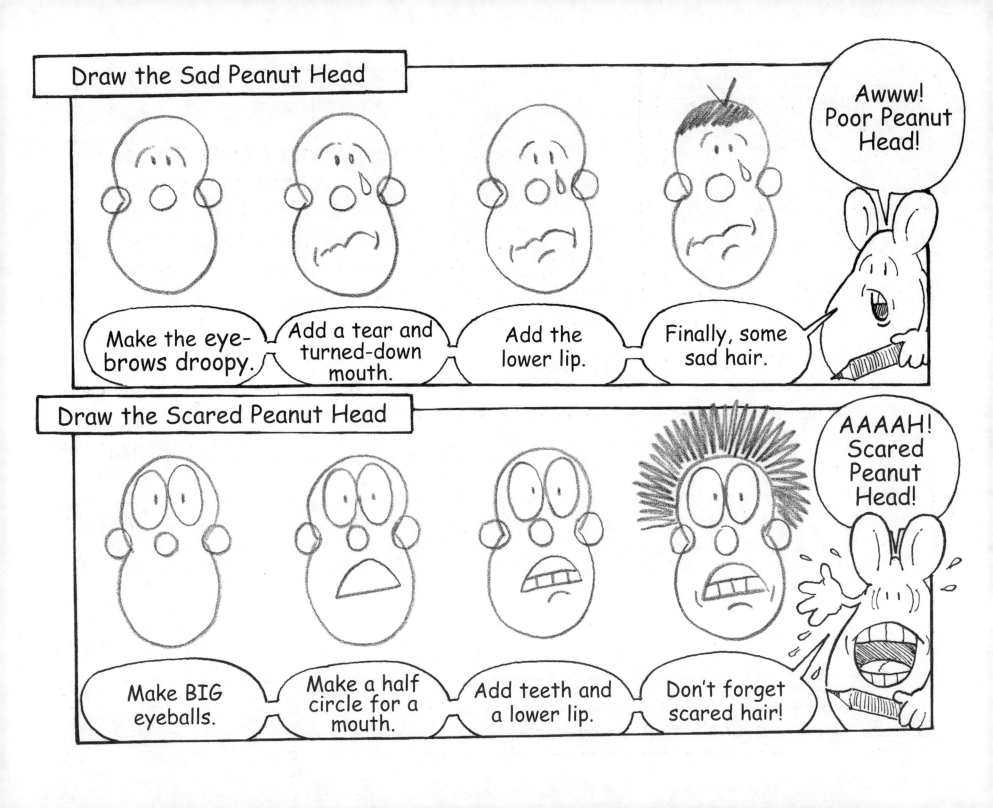

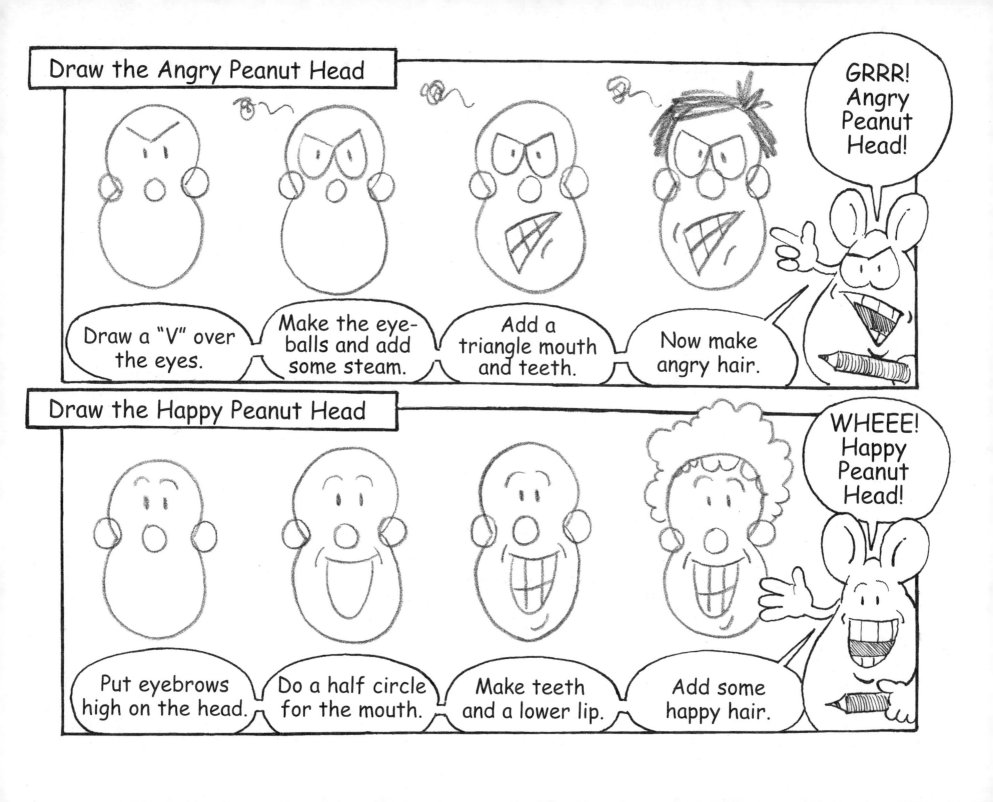

DRAWING SECRET #4
Use your imagination.

To be a good writer or artist you need to use your IMAGINATION! Imagination comes from the word IMAGE, which means picture.

Hmmm! What's imagination and how do I get some?

Imagination is being able to picture things like . . . a flying BeeBee!

COOL!

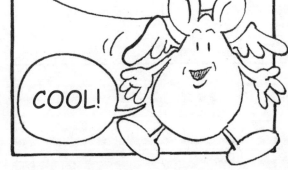

Imagination is being able to take things you've seen and change them around to make new things.

Like turning a doughnut into an alien . . .

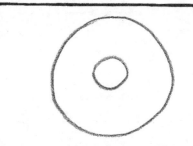

YEESH!

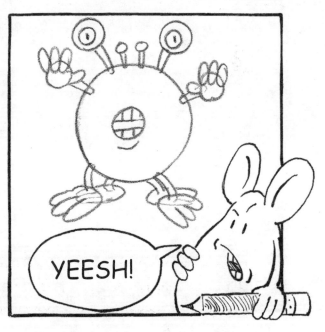

Okay, now you try. Let's use your imagination and make a shark out of a lemon shape.

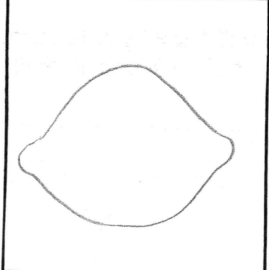

Draw a lemon shape.

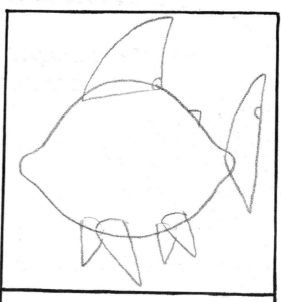

Add triangles for fins.

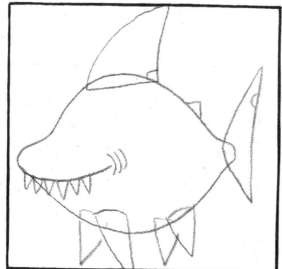

Add a line for a mouth and triangles for teeth.

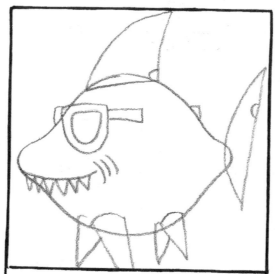

Make sunglasses using a half circle and a rectangle.

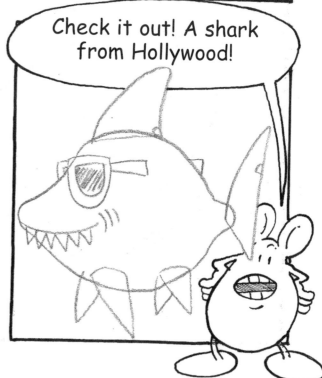

Check it out! A shark from Hollywood!

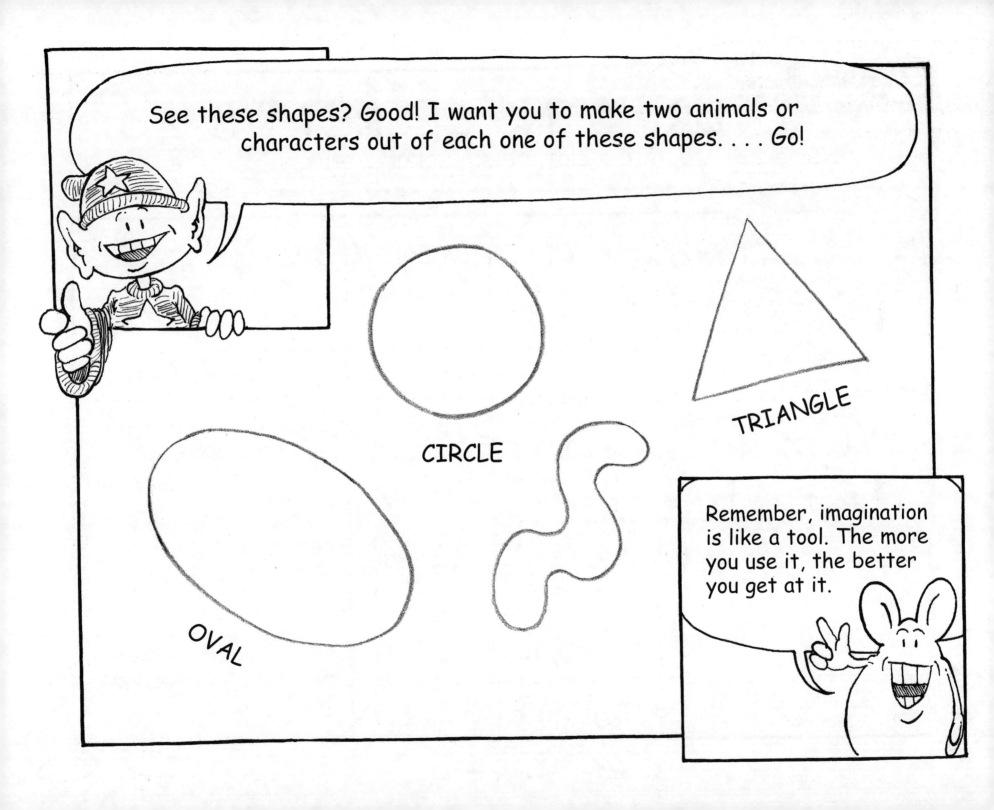

DRAWING SECRET #5
Putting clothes on a character.

Before you put clothes on a character, you draw the body first so the clothes fit right.

TA-DA!

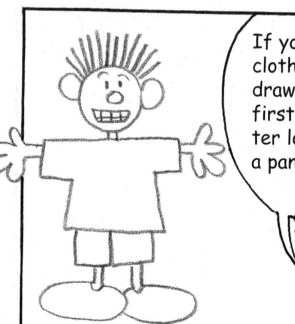

If you draw the clothes without drawing the body first, your character looks flat, like a pancake.

This is Captain Corn Chip. See how we drew the body first, then put his clothes on? Now turn the page and you try it.

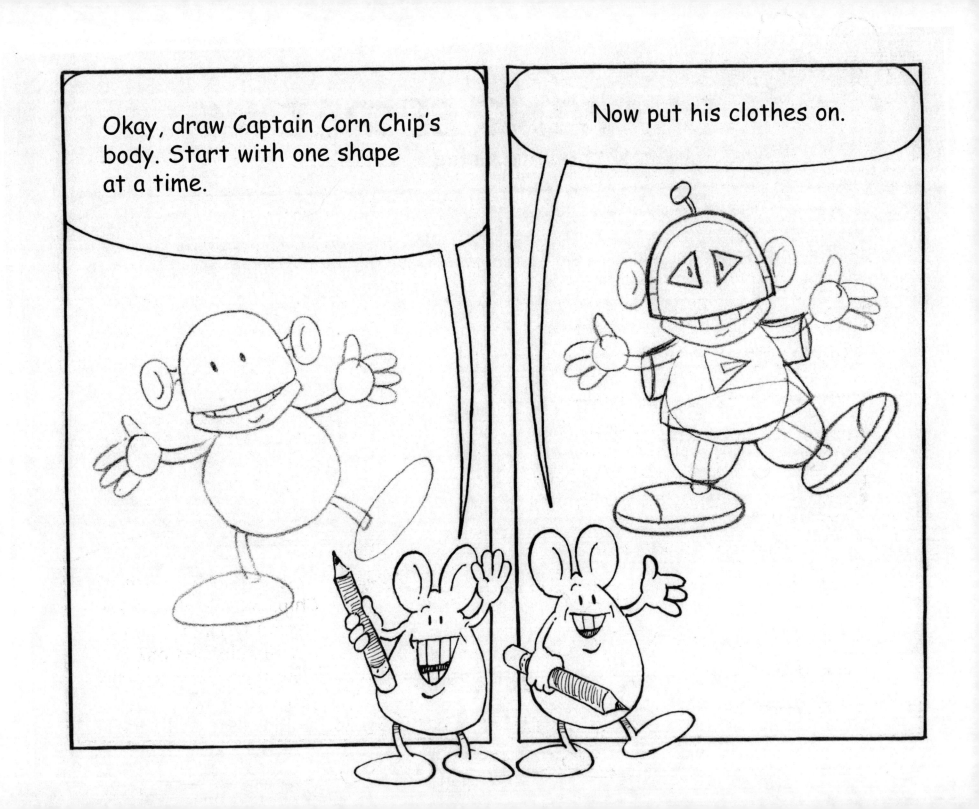

DRAWING SECRET #6
Draw the whole shape.

Let's give our superhero a cape. See how Captain Corn Chip's body covers up part of the cape? When one shape covers another you should draw the whole shape, like this. . . .

Now let's add a flying skateboard. Draw the whole shape. See? That way it comes out even.

Comic-book artists call this DRAWING THROUGH.

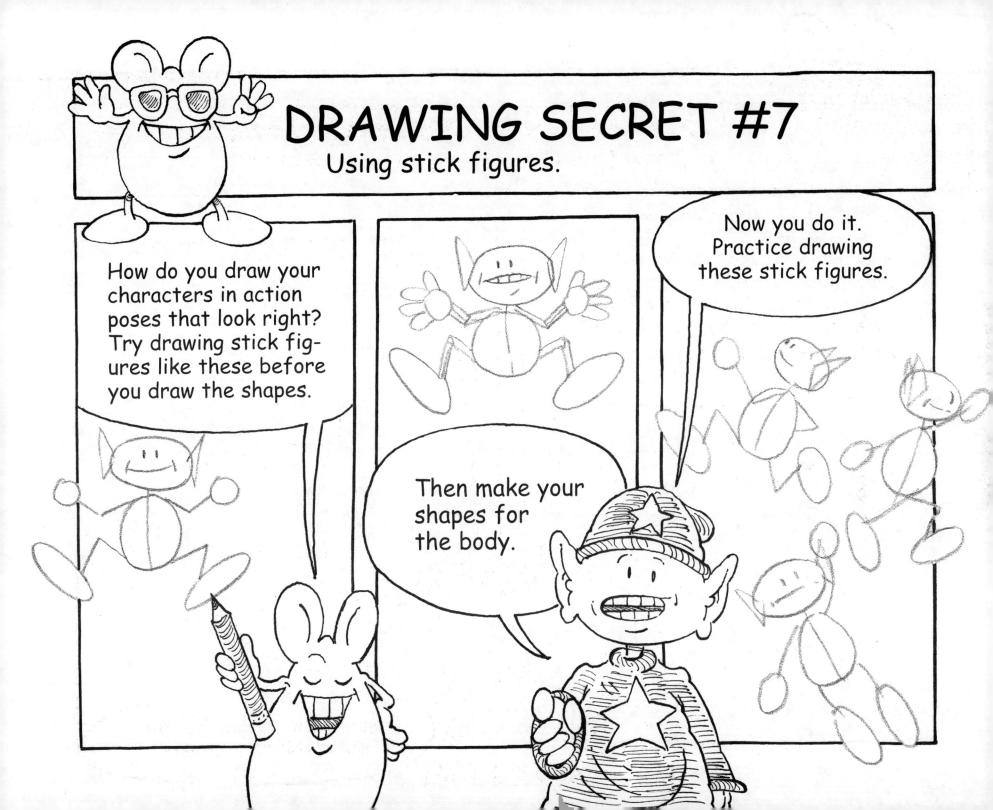

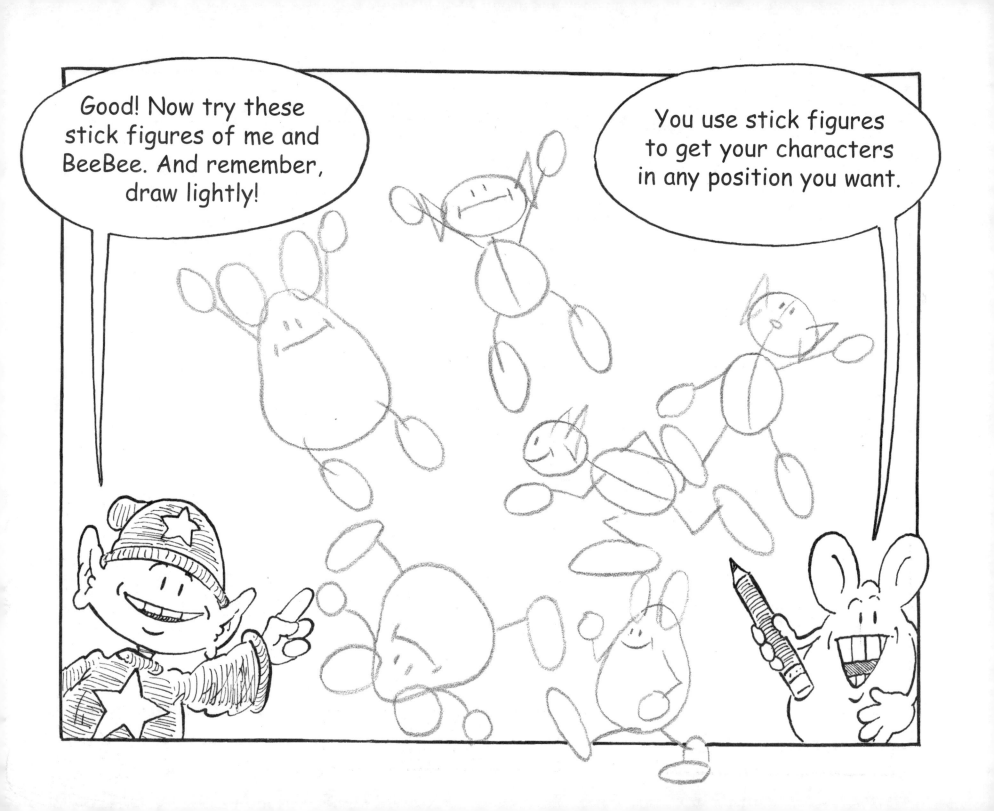

DRAWING SECRET #8

How to make things look like they pop off the page.

Now we'll show you some of the ways that artists make things look like they pop off the page!

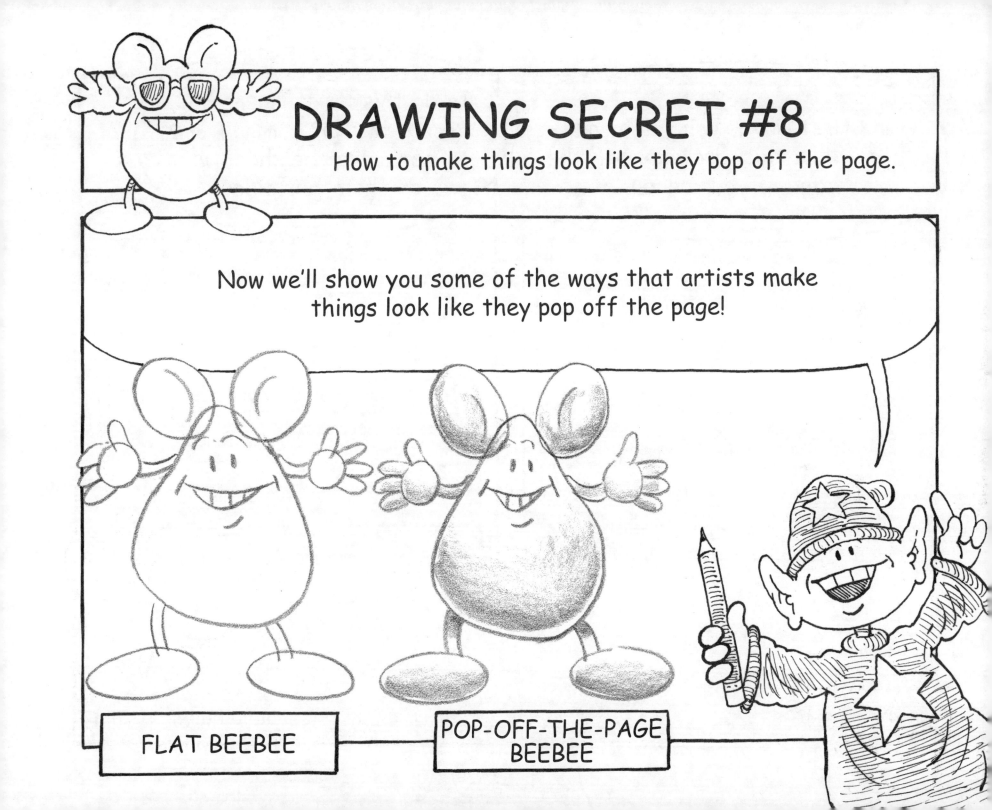

FLAT BEEBEE

POP-OFF-THE-PAGE BEEBEE

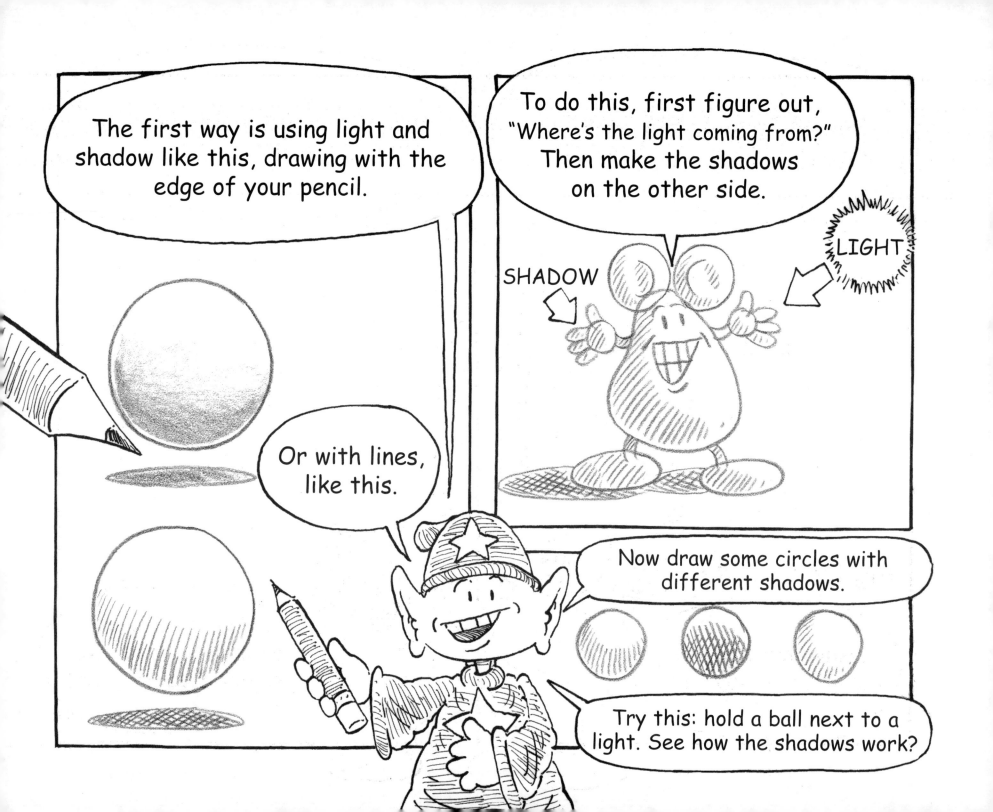

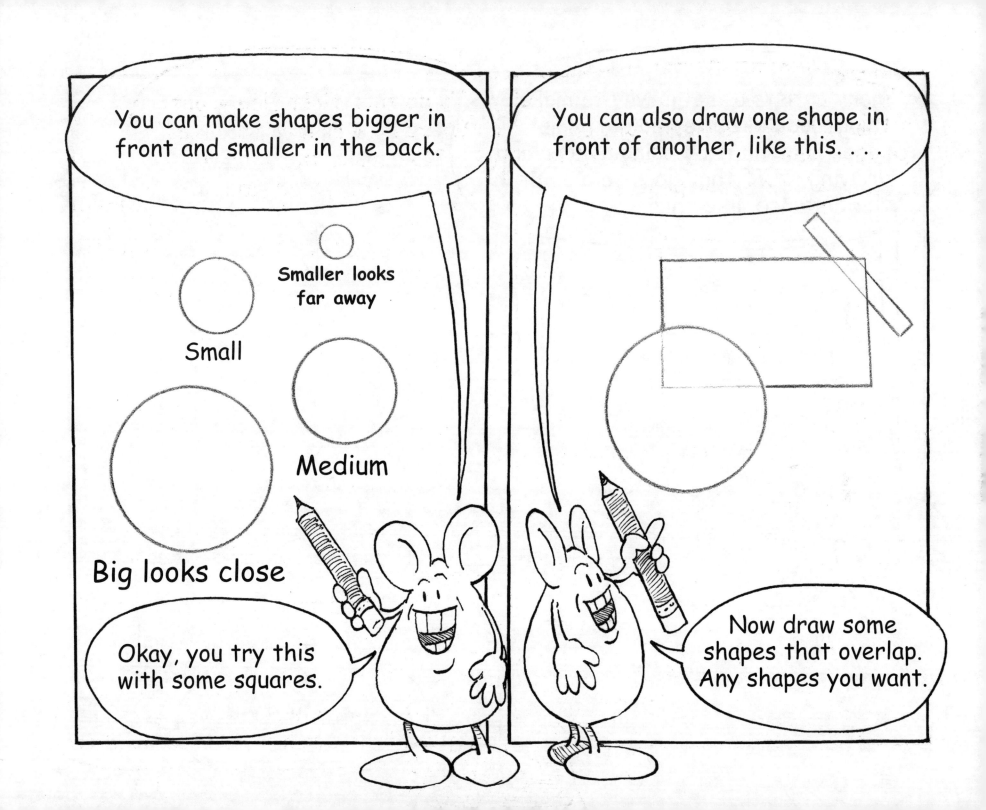

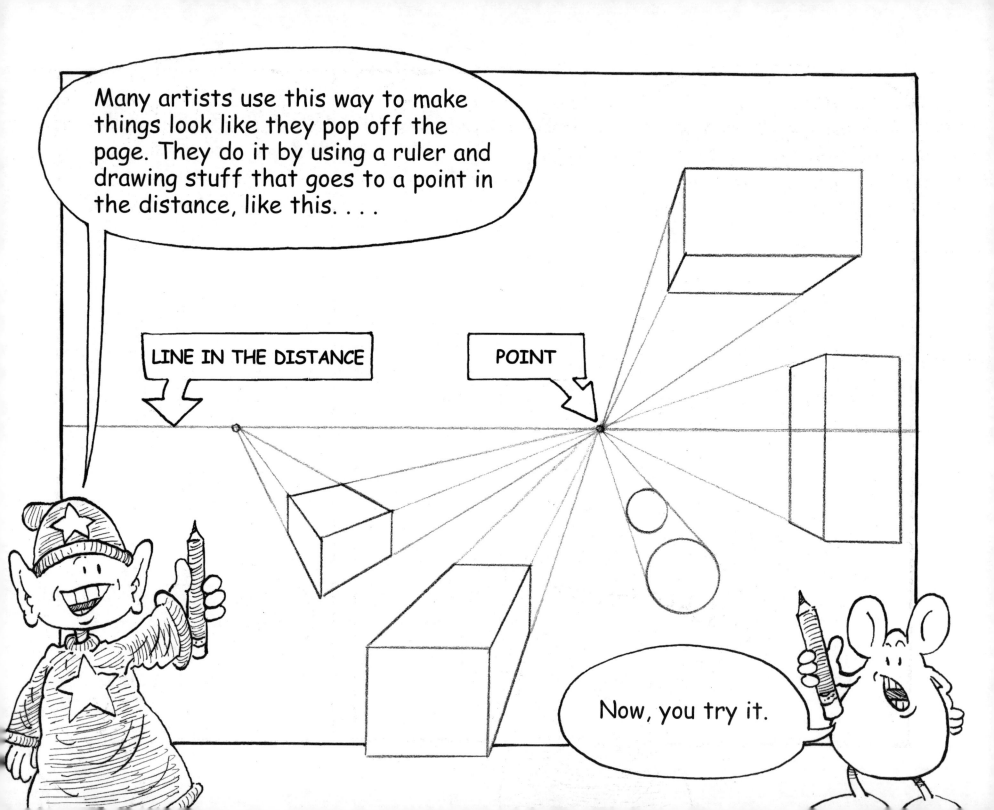

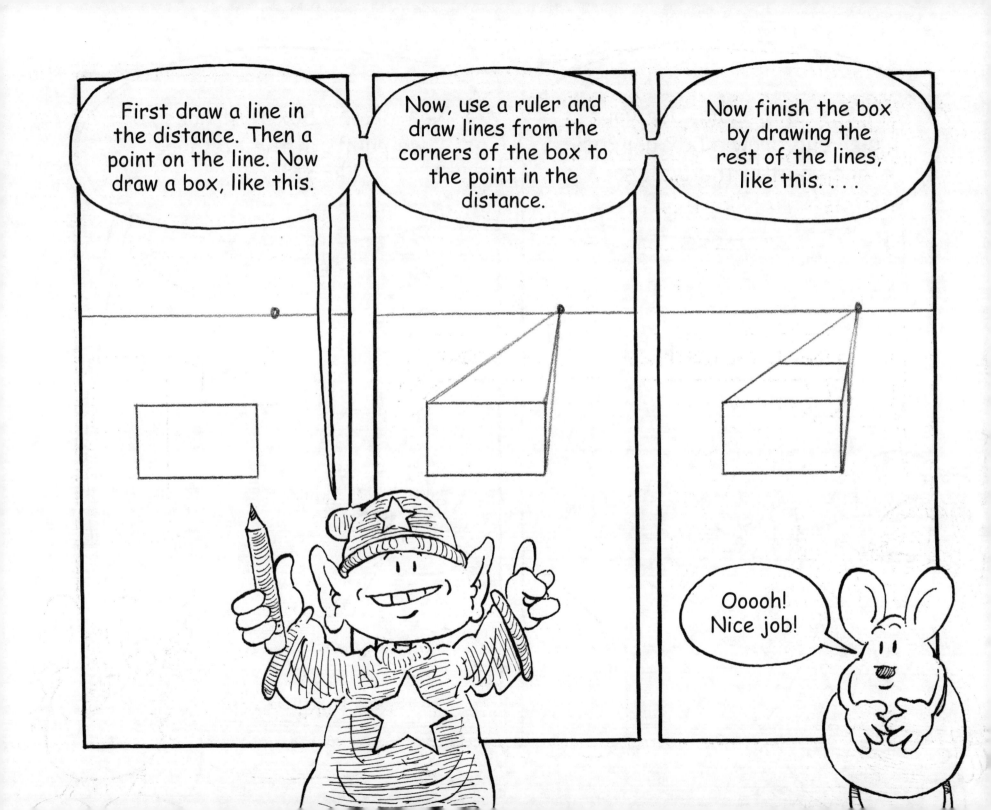

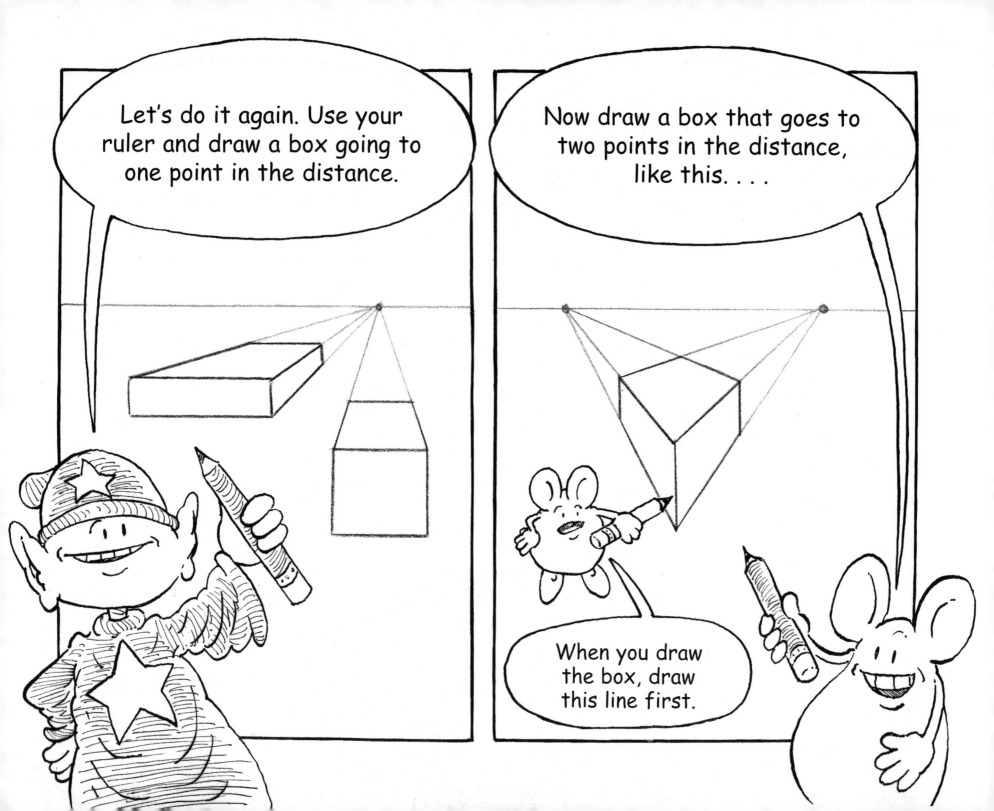

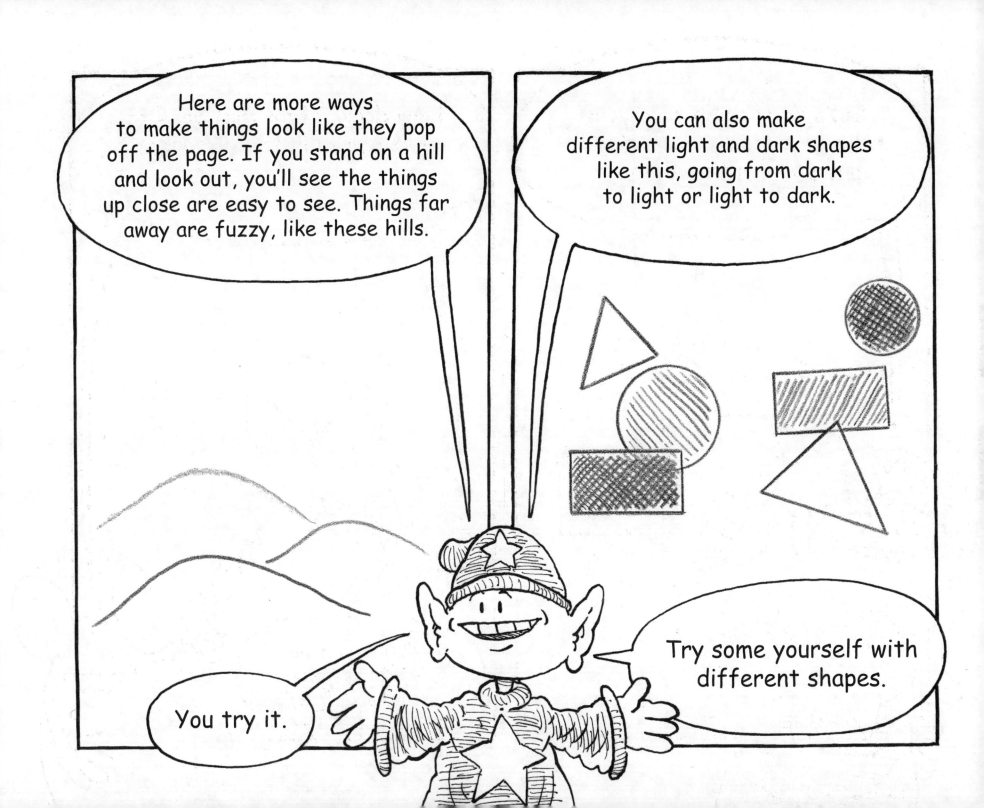

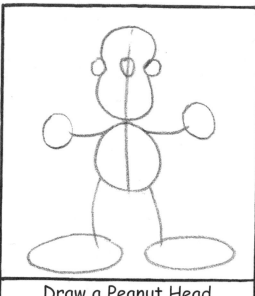

Draw a Peanut Head stick figure.

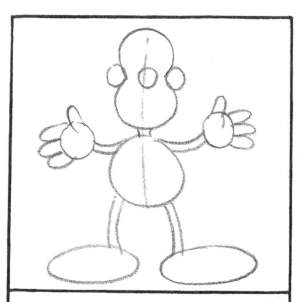

Draw the shapes for his body.

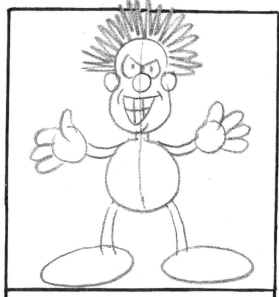

Add the face.

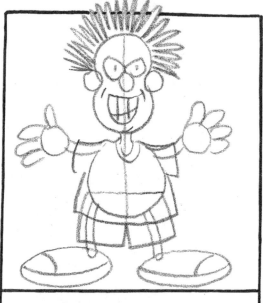

Now the clothes.

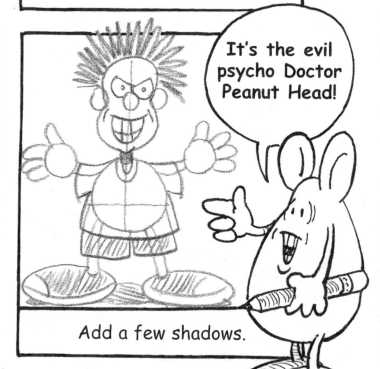

Add a few shadows.

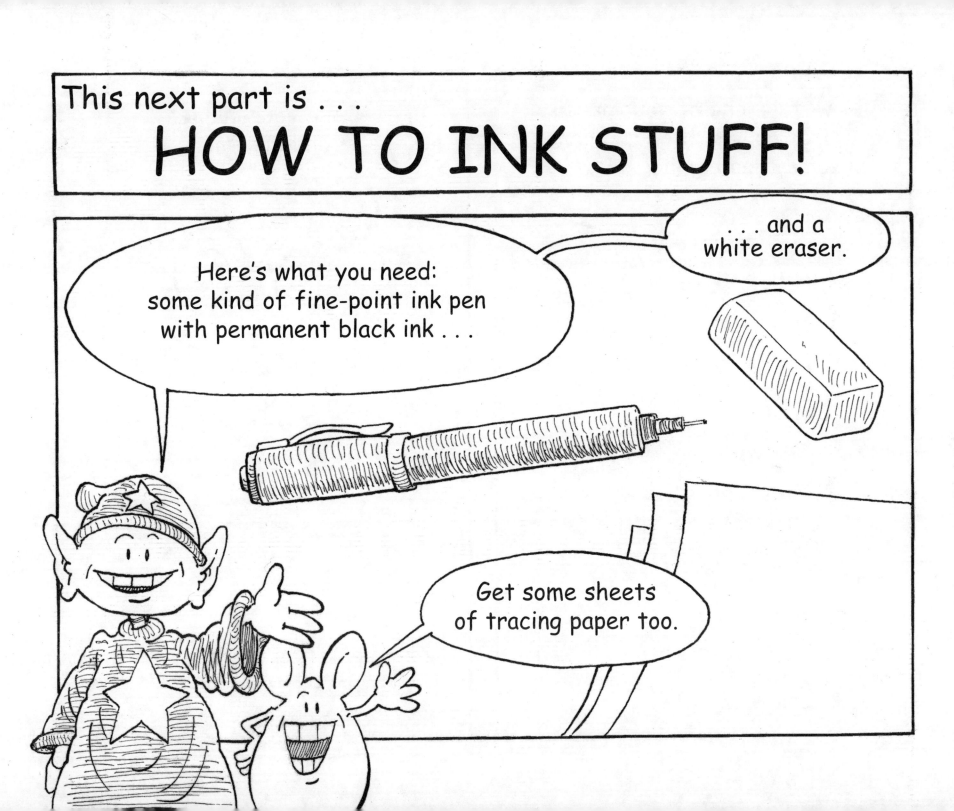

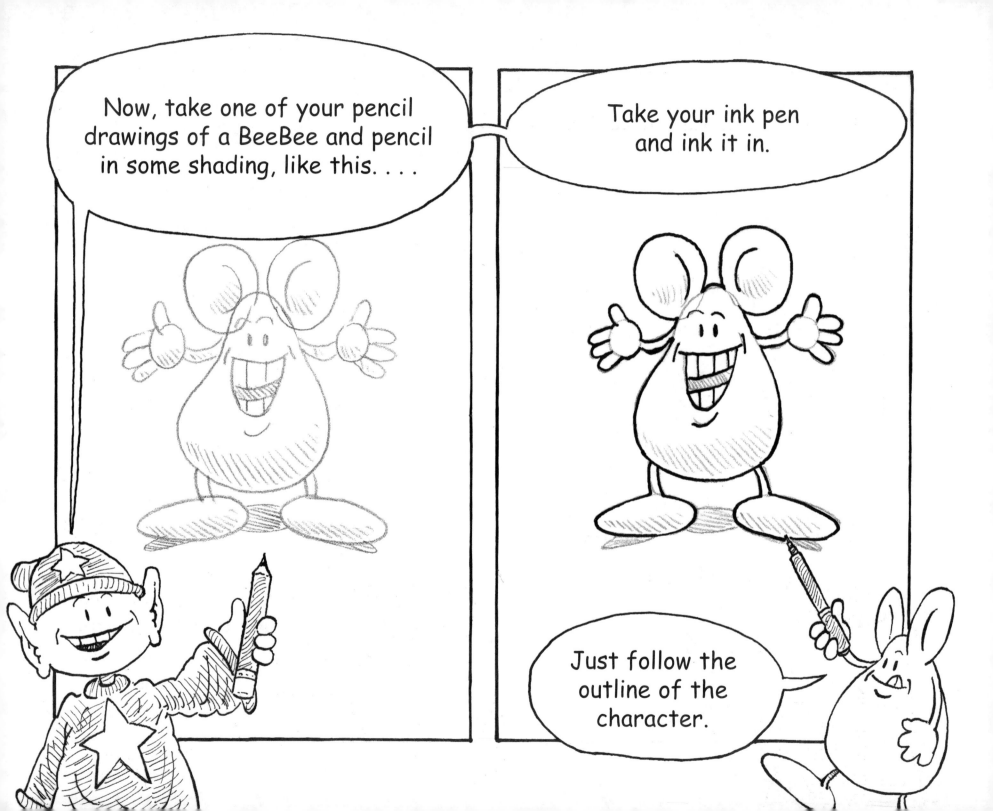

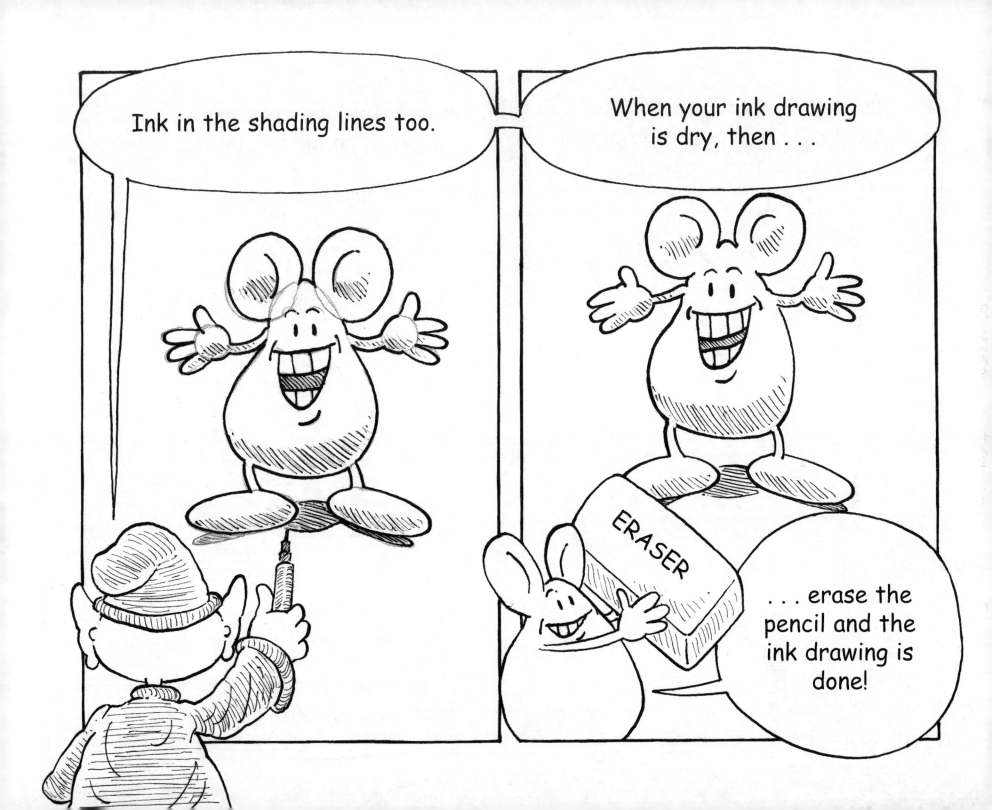

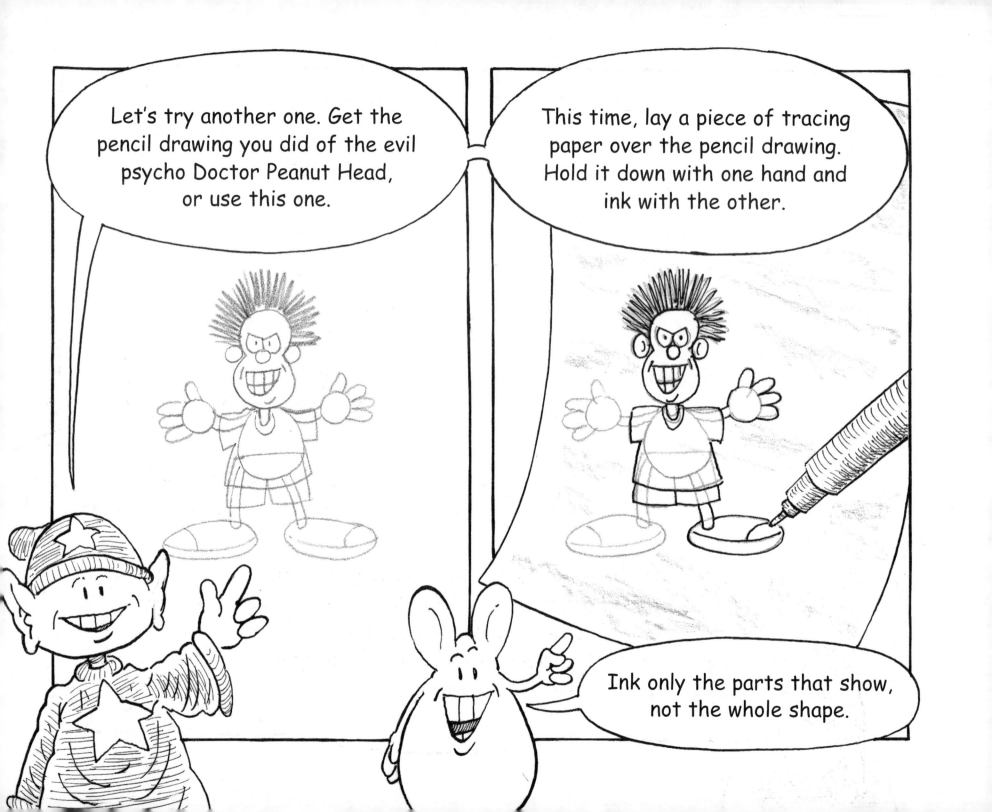

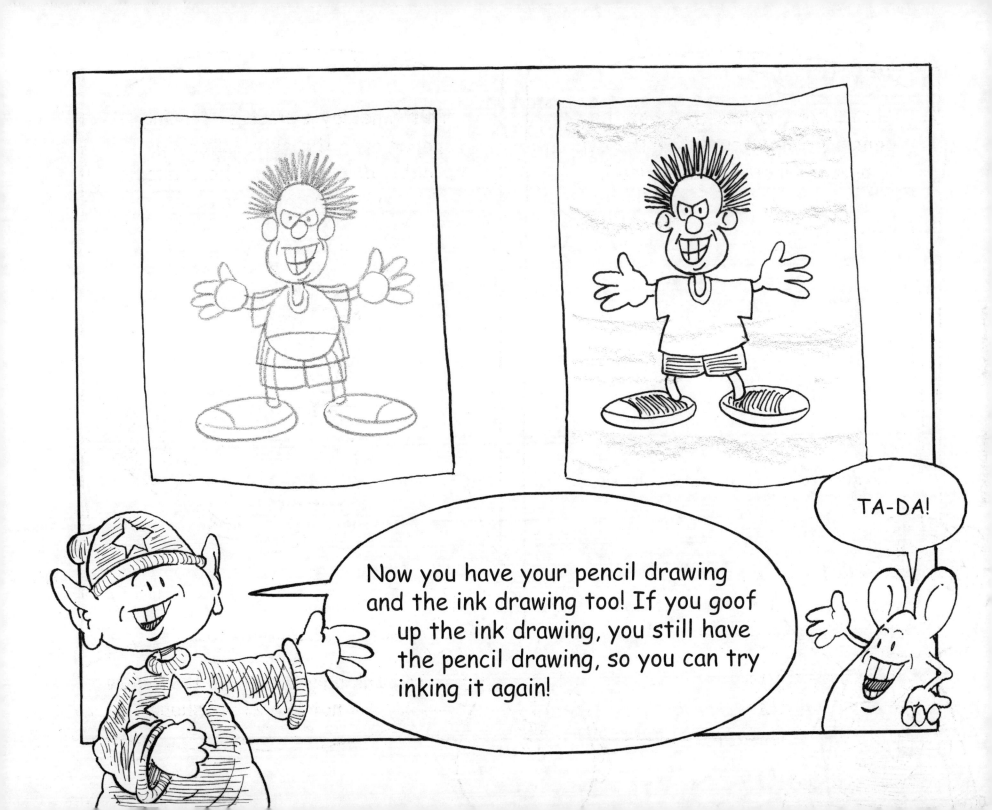

DRAWING SECRET #9
A good pencil drawing makes a good ink drawing.

YOU MUST HAVE A GOOD PENCIL DRAWING

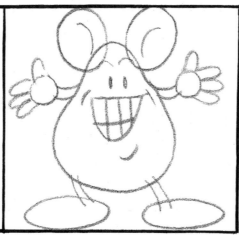

TO MAKE A GOOD INK DRAWING

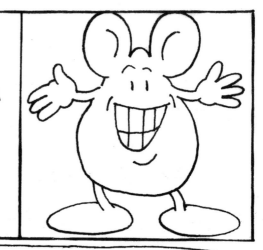

Okay, take some tracing paper and practice inking these characters.

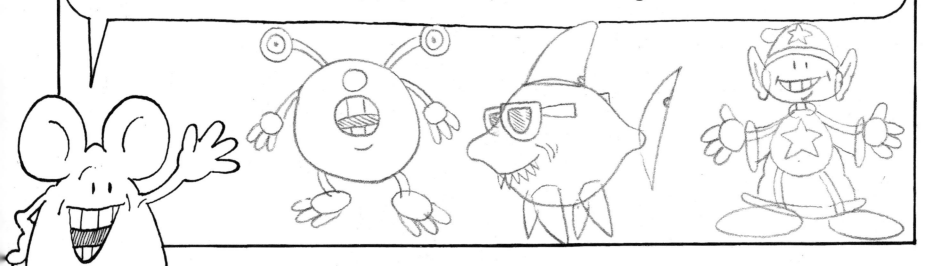

DRAWING SECRET #10
Don't try to draw perfectly.

AAAAAAAH!
I didn't draw it perfect!
I'm no good. I stink.
I hate this.
AAAAAAAH!

If you try to draw perfectly, you'll drive yourself crazy!
So, don't do that!

Yes, if you want to be a good artist you must practice, a lot. It's the only way.

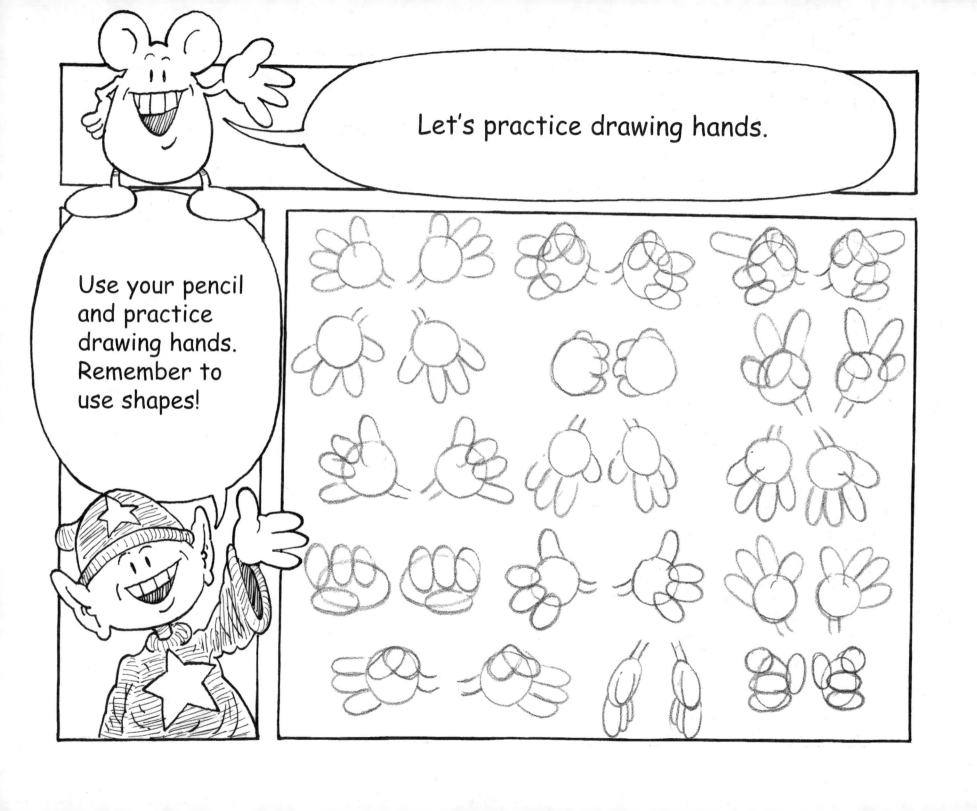

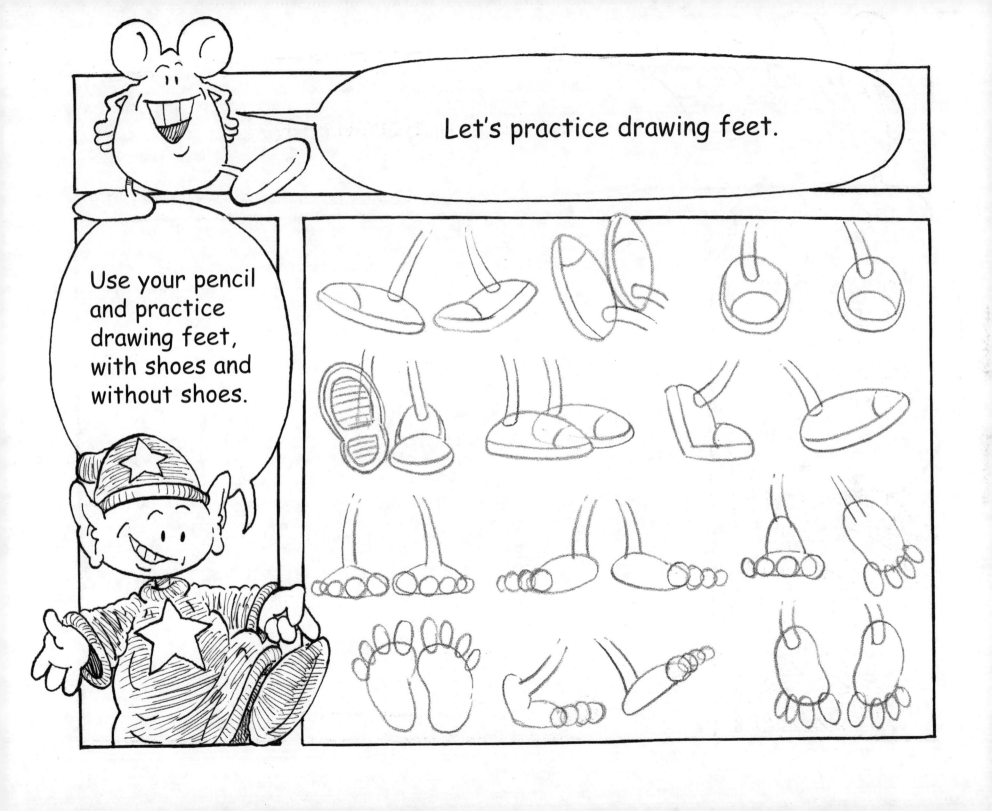

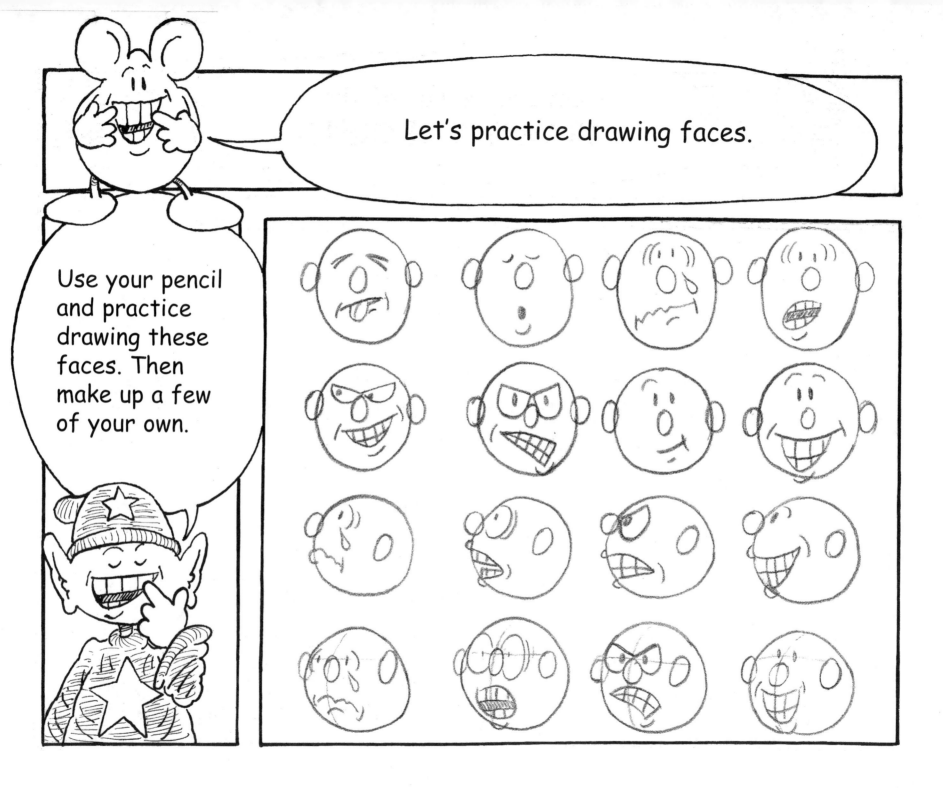

Let's review all of the
DRAWING SECRETS

1. Do all your drawings in pencil first before you ink, so you can erase if you goof.

2. Always break things down into easy-to-draw shapes.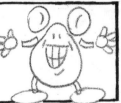

3. Pencil drawings should be done lightly.

4. Use your imagination.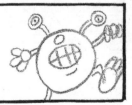

5. Draw the body lightly first, then draw the clothes.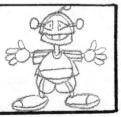

6. Even when a shape is in front of another one, draw the whole shape.

7. To get bodies in the right position, use stick figures.

8. Use shading and over-lapping shapes to make things look like they pop off the page.

9. You have to make a good pencil drawing to make a good ink drawing.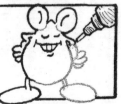

10. Don't try to draw perfectly. You get good by practicing. Have fun!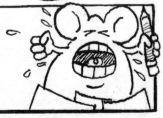

So . . . there you go. That's how to draw stuff. If you want to go back and practice some more, go ahead! Artists continue to practice their whole lives.

The more you practice, the better you get.

Right!

Here are some other books that will help you. Get them at your local bookstore:

"How to Draw Comics the Marvel Way"

by Stan Lee and John Buscema

"Cartooning the Head and Figure"

by Jack Hamm

To see more of my books, visit actionpublishing.com or ask your school librarian for books by Scott E. Sutton.